Dedicated to Anne-Lyse and Jaike, with all my love

- GB

CONTENTS

Tunes included in this volume are:

1. *Slowly Going Mad*
2. *Dream Funk*
3. *Blue When Sunny Gets*
4. *Cous-Cous for Coco*
5. *Why Don't You Just Speak Whale to Me?*
6. *Port Royal*
7. *Three Legged Dog*
8. *Metro Blues*
9. *Caught Between a Rock and a Hard Place*
10. *Secrets D'Histoire*
11. *Spring Can Really Hang You Up*
12. *Skating in Central Park Too*

SONG LIST .. 3
INTRODUCTION .. 4

𝄞 CONCERT KEY SONGS & CHORD/SCALE PROGRESSIONS 5

B♭ B♭ INSTRUMENT SONGS & CHORD/SCALE PROGRESSIONS 17

E♭ E♭ INSTRUMENT SONGS & CHORD/SCALE PROGRESSIONS 29

𝄢 BASS CLEF SONGS & CHORD/SCALE PROGRESSIONS 41

Copyright © 2012, Philip Gordon
All Rights Reserved

ISBN 978-0-9847638-9-4
Library of Congress Control Number: 2011919233

Blue Matrix Publications
USA: 2995 Woodside Rd. Suite 400, Woodside, CA 94062
France: 2 rue Despaty, Voisines, FR 89260
www.bluematrix.org

Music Engraving by W.R. Music Service

Printed in the United States of America

INTRODUCTION

Secrets d'Histoire contains jazz compositions written for the Zodiac Project (*Volume 1: Philip "Flip" Gordon: Jazz Compositions: Zodiac Project: Parallel Universe*) and adapted from earlier projects while playing music and leading bands both in San Francisco, California and Paris, France.

Philip "Flip" Gordon's musical journey carried him from United States to Europe over a span of 30 years. He performed, studied and played music with some of the very best and talented musicians of his era. Some of which to name a few: *Wayne Shorter, Joe Henderson, Mark Levine, Art Farmer, Harold Land, Joe Lovano, Rufus Reid, Joe Thornton, David Lieberman and* also recognizing his influences: *Ben Webster, Stan Getz, Sonny Rollins and John Coltrane.*

Originally self-taught, with an active career in jazz clubs, he later studied and attended jazz schools and music conservatories, including: The *Blue Bear School of Music and the Jazz School in Northern California, and the American School Modern Music, Scala Conturum Conservatoire and ARPEJ in Paris.*

He has performed with his groups, the Out of Nowhere Bands (quartets to sextets), and individually, including: television, radio, music festivals, corporate events, weddings and five-star hotels (*Four Seasons, George V, Hotel Triton*, etc.) throughout California and Europe. His groups have included outstanding musicians and vocalists such as: *Jacqui Naylor, Frankye Kelly, Millicent Woods, David Hartman, Jeff Cressman, Marlin B. Greene, Roscoe Gallo, Jeremy Cohen,* etc. (the list goes on and on, too numerous to name here).

Flip was born in Pittsburgh, Pennsylvania in 1953, and choose a full-time music journey in 1994 while living in Palo Alto California; where he was "doubling" his profession with design. Most of the compositions in this Volume 2 follow the principle ideas that culminated in the Volume 1, yet open a wider conceptual compositional range for improvisation. (While living in Paris, he was surrounded by musical "phenomena"; being exposed to many great artists and musicians that were part of his everyday life in the Latin Quarter – *just next door to where Miles Davis* lived in the 60's). Two of these compositions: *Slowly Going Mad* and *Caught between a Rock and a Hard Place,* are musical interpretations of how one perceives the journey through life. *Dream Funk, Metro Blues and Secrets* are alignments between the conscious and subconscious reality. *Why Don't You Speak Whale to Me?* illustrating the connection between telling a story and how it is eventually interpreted when heard throughout the world (similar to the way whales communicate). *Blue When Sunny Gets, Cous-cous for Coco,* and *Three-Legged Dog* are impressions about the events and occurrences of daily events in the neighborhoods, parks and streets of Paris. *Spring can Hang you up the Most and Skating in Central Park* are two of his adapted favorite performance standards (springtime always was his preferred season, and New York… well, you know).

To understand the context for these compositions, it would be useful to refer to: *Volume 1: Philip "Flip" Gordon: Jazz Compositions: Zodiac Project: Parallel Universe,* as a point of departure. Visiting the website at www.bluematrix.org may also be helpful.

Enjoy!

Philip "Flip" Gordon
Burgundy, France 2012

1. SLOWLY GOING MAD

Philip "Flip" Gordon
February, 2009
Paris, France

2. DREAM FUNK

Philip "Flip" Gordon
May, 2006
Paris, France

3. BLUE WHEN SUNNY GETS

Philip "Flip" Gordon
February, 2008
Paris, France

4. COUS-COUS for COCO

Philip "Flip" Gordon
January, 2004
Paris, France

5. WHY DON'T YOU JUST SPEAK WHALE TO ME?

Philip "Flip" Gordon
June, 2008
Paris, France

Up Tempo ♩ = 220
Drum Intro open

This song it ain't true jive. Same tune it ain't new Dig this... Each phrase is gon-na be jazz. Like whales in th' deep blue Hip whales in th' deep blue Why don't you just, Why don't you just speak whale to me

TO SOLOS

Why don't you just, Why don't you just speak whale to me.

SOLOS

© All Rights Reserved, By Permission Only: Blue Matrix Productions

6. PORT ROYAL

Philip "Flip" Gordon
October, 2008
Paris, France

7. THREE-LEGGED DOG

Philip "Flip" Gordon
August, 2007
Paris, France

Median swing ♩ = 60

© All Rights Reserved, By Permission Only: Blue Matrix Productions

8. METRO BLUES

Philip "Flip" Gordon
January, 2004
Paris, France

Blues with funk beat ♩ = 120

9. CAUGHT BETWEEN a ROCK and a HARD PLACE

Rogers/Hart - Philip "Flip" Gordon
June, 2008
Paris, France

10. SECRETS D'HISTOIRE

Warden/Philip "Flip" Gordon
October, 2008
Paris, France

11. SPRING CAN REALLY HANG YOU UP

Wolf/Gordon//Philip "Flip" Gordon
April, 2008
Paris, France

Median Ballad ♩ = 80

| Cmaj7 | B♭13 | Cmaj7 | Cmaj7 | B♭13 | Cmaj7 | B♭m7 | A♭maj7 |

| F#m7 | Emaj7 | Dm7 | Cmaj7 | Am9 | Dm9 | G7 | Cmaj7 | A7(♭9) |

| Dm7(11) | A7(♭9/#5) | D9 | G13 | Cmaj7 | B♭maj9 | Cmaj7 | B♭maj9 | Cmaj7 | Am7 | Dm7 | G7 |

| Em7 | A7(♭9) | F#m7(♭5) | Fm7 | Em7 | D7 | Dm7 | G7 | Cmaj7 | B♭maj7 |

| Cmaj7 | B♭maj9 | Cmaj7 | B♭maj9 | Cmaj7 | Am7 | Dm7 | G7 | Em7 | A7(♭9) |

TO SOLOS

| F#m7(♭5) | Fm7 | Em7 | D7 | Dm7 | G7 | Cm7 |

SOLOS

| Cmaj7 | B♭13 | Cmaj7 | Cmaj7 | B♭13 | Cmaj7 | B♭m7 | A♭maj7 |

| F#m7 | Emaj7 | Dm7 | Cmaj7 | Am9 | Dm9 | G7 | Cmaj7 | A7♭9 |

| Dm7(11) | A7(♭9/#5) | D9 | G13 | Cmaj7 | B♭maj9 | Cmaj7 | B♭maj9 | Cmaj7 | Am7 | Dm7 | G7 |

| Em7 | A7(♭9) | F#m7(♭5) | Fm7 | Em7 | D7 | Dm7 | G7 | Cmaj7 | B♭maj7 |

| Cmaj7 | B♭maj9 | Cmaj7 | B♭maj9 | Cmaj7 | Am7 | Dm7 | G7 | Em7 | A7(♭9) |

| F#m7(♭5) | Fm7 | Em7 | D7 | Dm7 | G7 | Cm7 |

© All Rights Reserved, By Permission Only: Blue Matrix Productions

12. SKATING IN CENTRAL PARK TOO

John Lewis
Adapted Philip "Flip" Gordon
August, 2008
Paris, France

Median slow ♩ = 80

1. SLOWLY GOING MAD

Philip "Flip" Gordon
February, 2009
Paris, France

2. DREAM FUNK

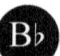

Philip "Flip" Gordon
May, 2006
Paris, France

4. COUS-COUS for COCO

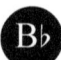

Philip "Flip" Gordon
January, 2004
Paris, France

Median swing ♩ = 60

5. WHY DON'T YOU JUST SPEAK WHALE TO ME?

Philip "Flip" Gordon
June, 2008
Paris, France

© All Rights Reserved, By Permission Only: Blue Matrix Productions

6. PORT ROYAL

Philip "Flip" Gordon
October, 2008
Paris, France

7. THREE-LEGGED DOG

Philip "Flip" Gordon
August, 2007
Paris, France

8. METRO BLUES

Philip "Flip" Gordon
January, 2004
Paris, France

B♭

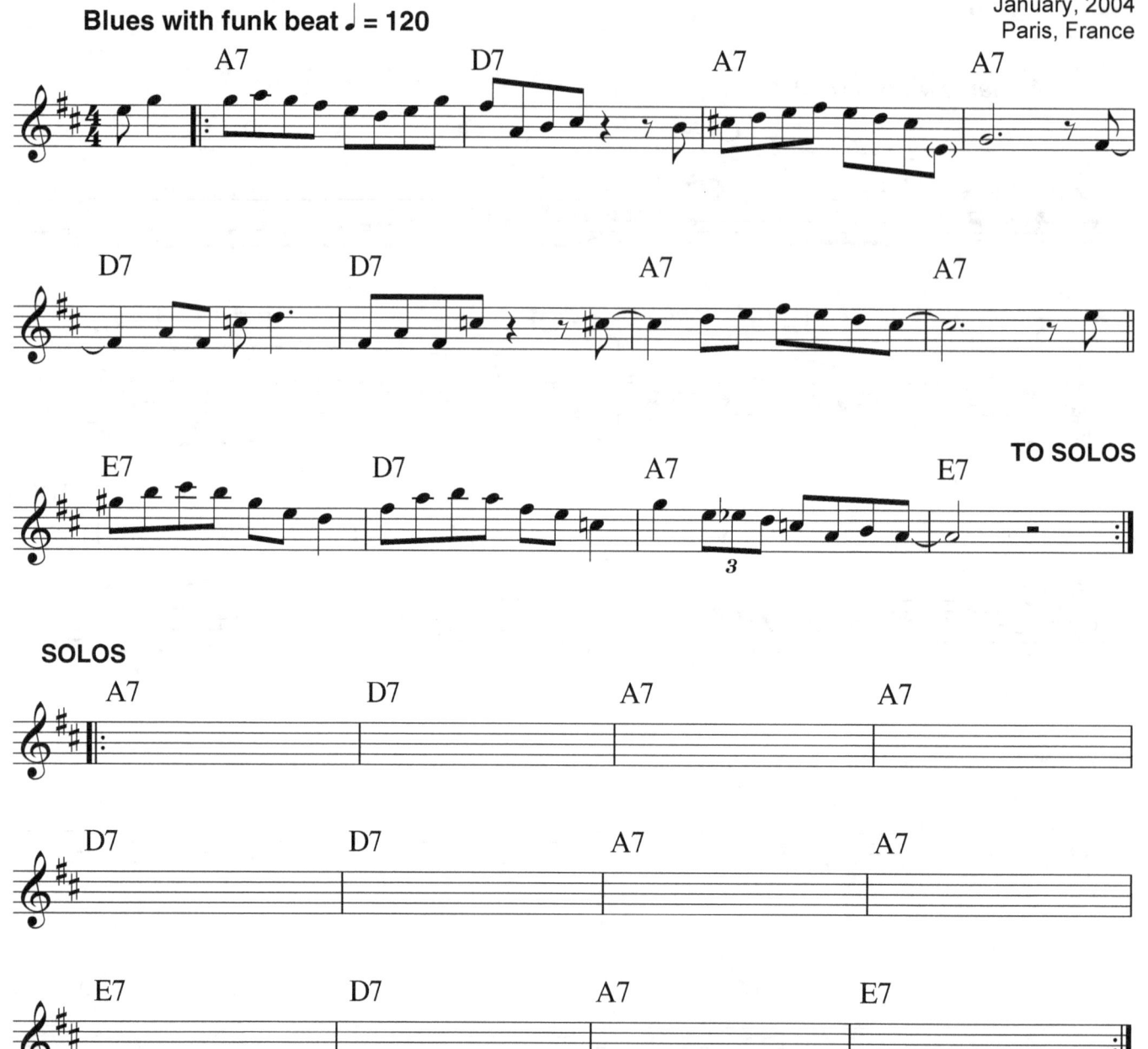

9. CAUGHT BETWEEN a ROCK and a HARD PLACE

Rogers/Hart - Philip "Flip" Gordon
June, 2008
Paris, France

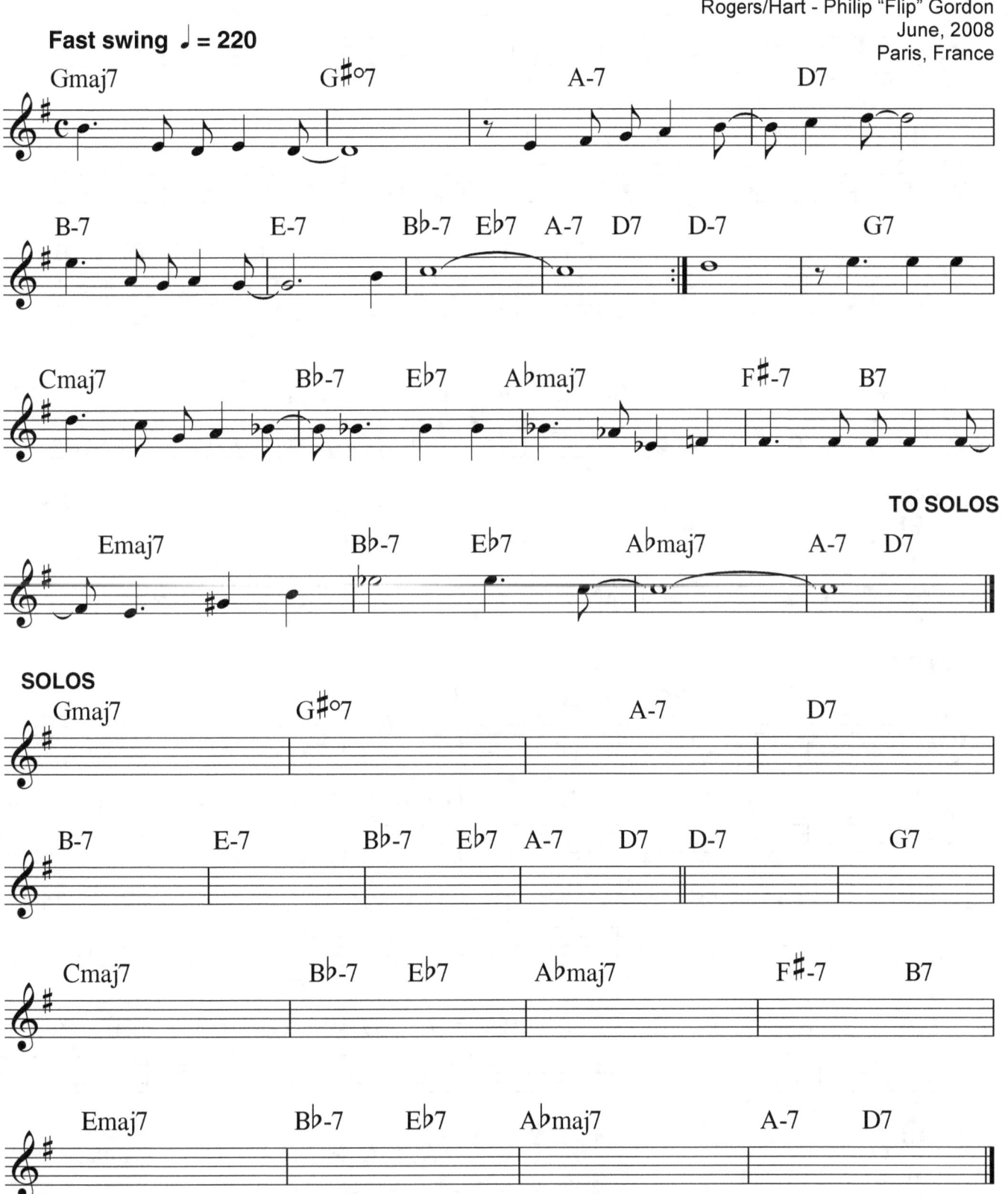

10. SECRETS D'HISTOIRE

Warden/Philip "Flip" Gordon
October, 2008
Paris, France

11. SPRING CAN REALLY HANG YOU UP

Wolf/Gordon//Philip "Flip" Gordon
April, 2008
Paris, France

Median Ballad ♩ = 80

12. SKATING IN CENTRAL PARK TOO

John Lewis
Adapted Philip "Flip" Gordon
August, 2008
Paris, France

1. SLOWLY GOING MAD

Philip "Flip" Gordon
February, 2009
Paris, France

2. DREAM FUNK

Philip "Flip" Gordon
May, 2006
Paris, France

3. BLUE WHEN SUNNY GETS

Philip "Flip" Gordon
February, 2008
Paris, France

E♭

Median swing ♩ = 52

4. COUS-COUS for COCO

Philip "Flip" Gordon
January, 2004
Paris, France

© All Rights Reserved, By Permission Only: Blue Matrix Productions

5. WHY DON'T YOU JUST SPEAK WHALE TO ME?

Philip "Flip" Gordon
June, 2008
Paris, France

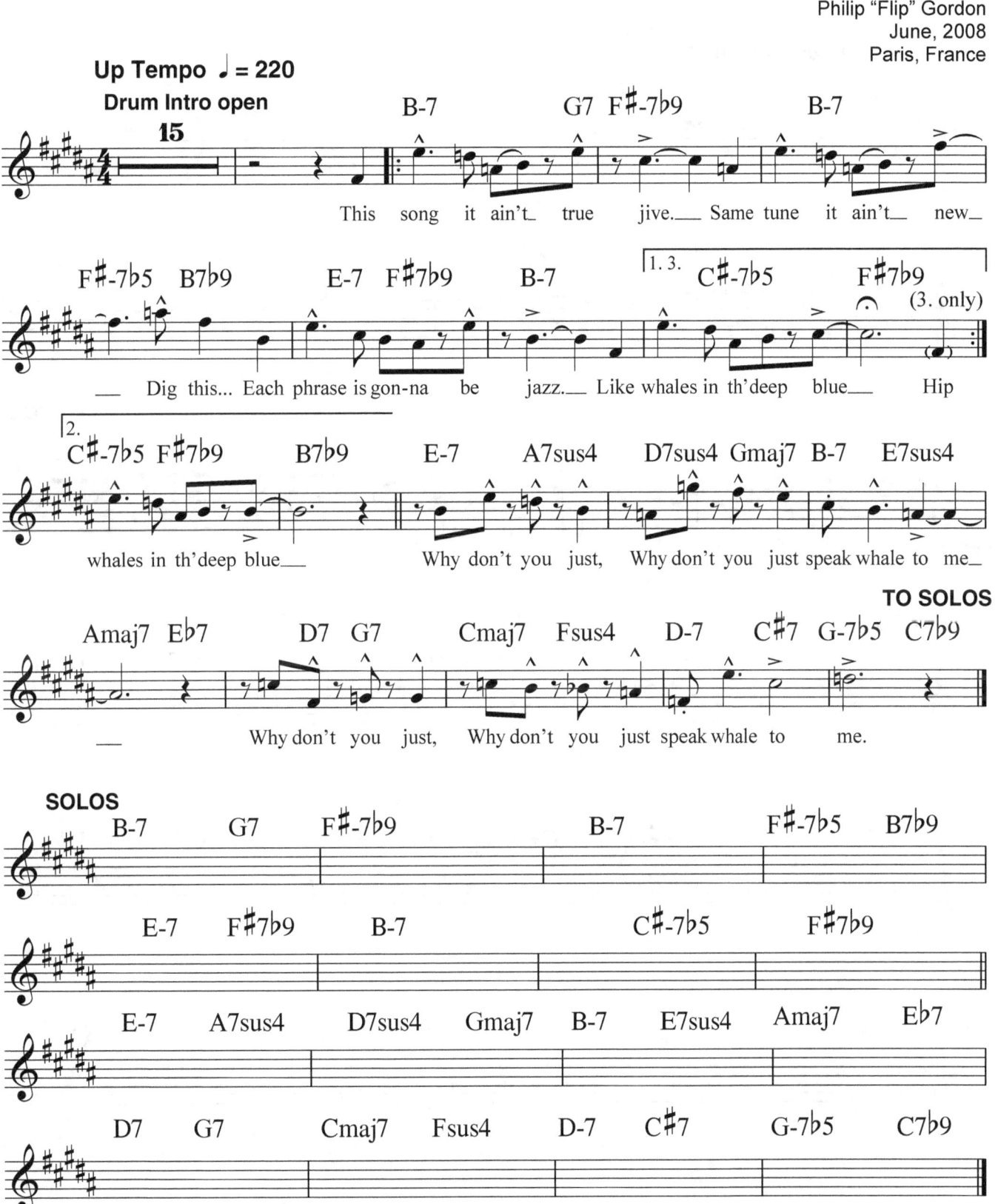

6. PORT ROYAL

Philip "Flip" Gordon
October, 2008
Paris, France

7. THREE-LEGGED DOG

Philip "Flip" Gordon
August, 2007
Paris, France

8. METRO BLUES

Philip "Flip" Gordon
January, 2004
Paris, France

Blues with funk beat ♩ = 120

9. CAUGHT BETWEEN a ROCK and a HARD PLACE

Rogers/Hart - Philip "Flip" Gordon
June, 2008
Paris, France

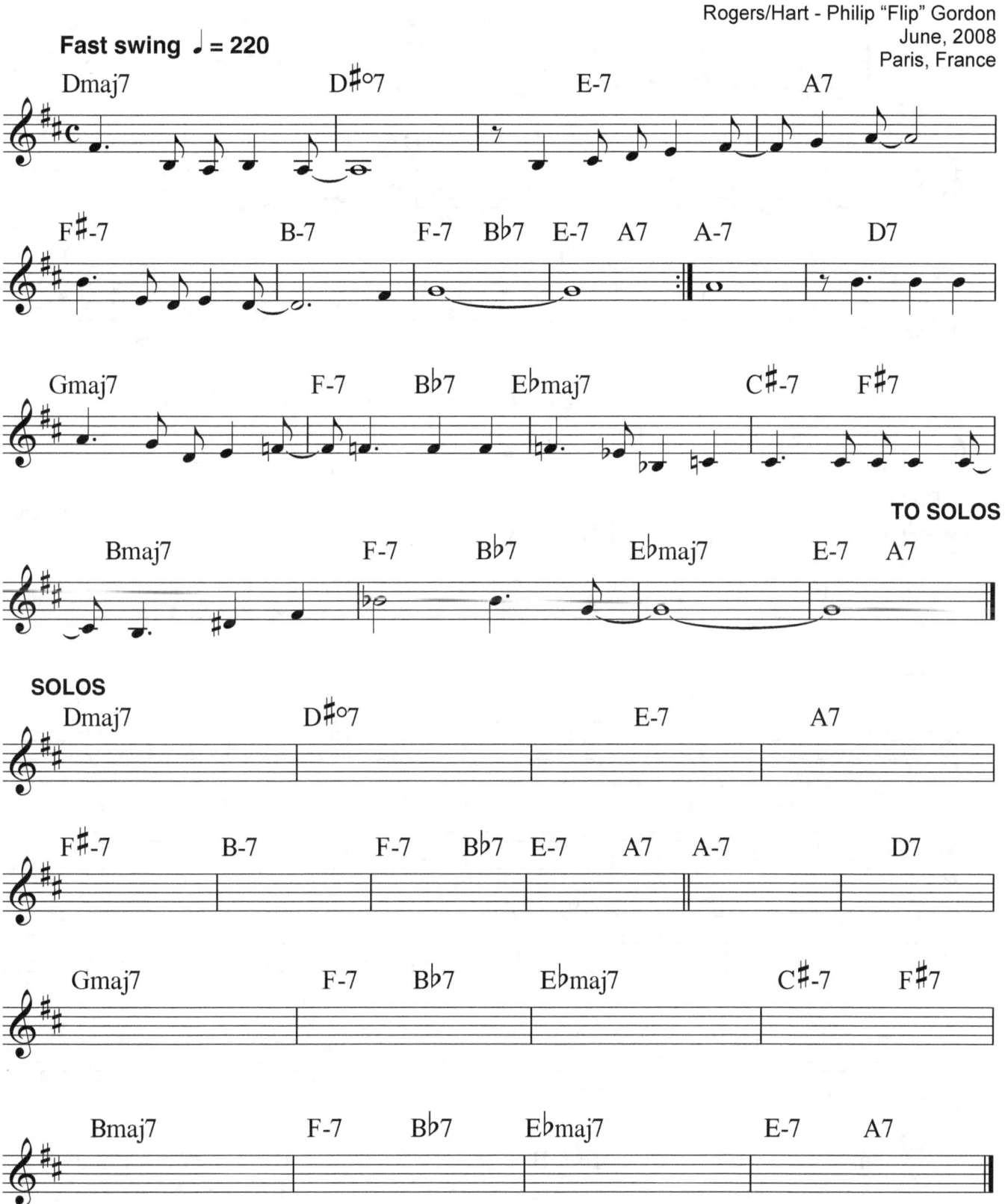

10. SECRETS D'HISTOIRE

Warden/Philip "Flip" Gordon
October, 2008
Paris, France

11. SPRING CAN REALLY HANG YOU UP

Wolf/Gordon//Philip "Flip" Gordon
April, 2008
Paris, France

Median Ballad ♩ = 80

12. SKATING IN CENTRAL PARK TOO

John Lewis
Adapted Philip "Flip" Gordon
August, 2008
Paris, France

Median slow ♩ = 80

1. SLOWLY GOING MAD

Philip "Flip" Gordon
February, 2009
Paris, France

Intro: (Open) "Crazy"

2. DREAM FUNK

Philip "Flip" Gordon
May, 2006
Paris, France

3. BLUE WHEN SUNNY GETS

Philip "Flip" Gordon
February, 2008
Paris, France

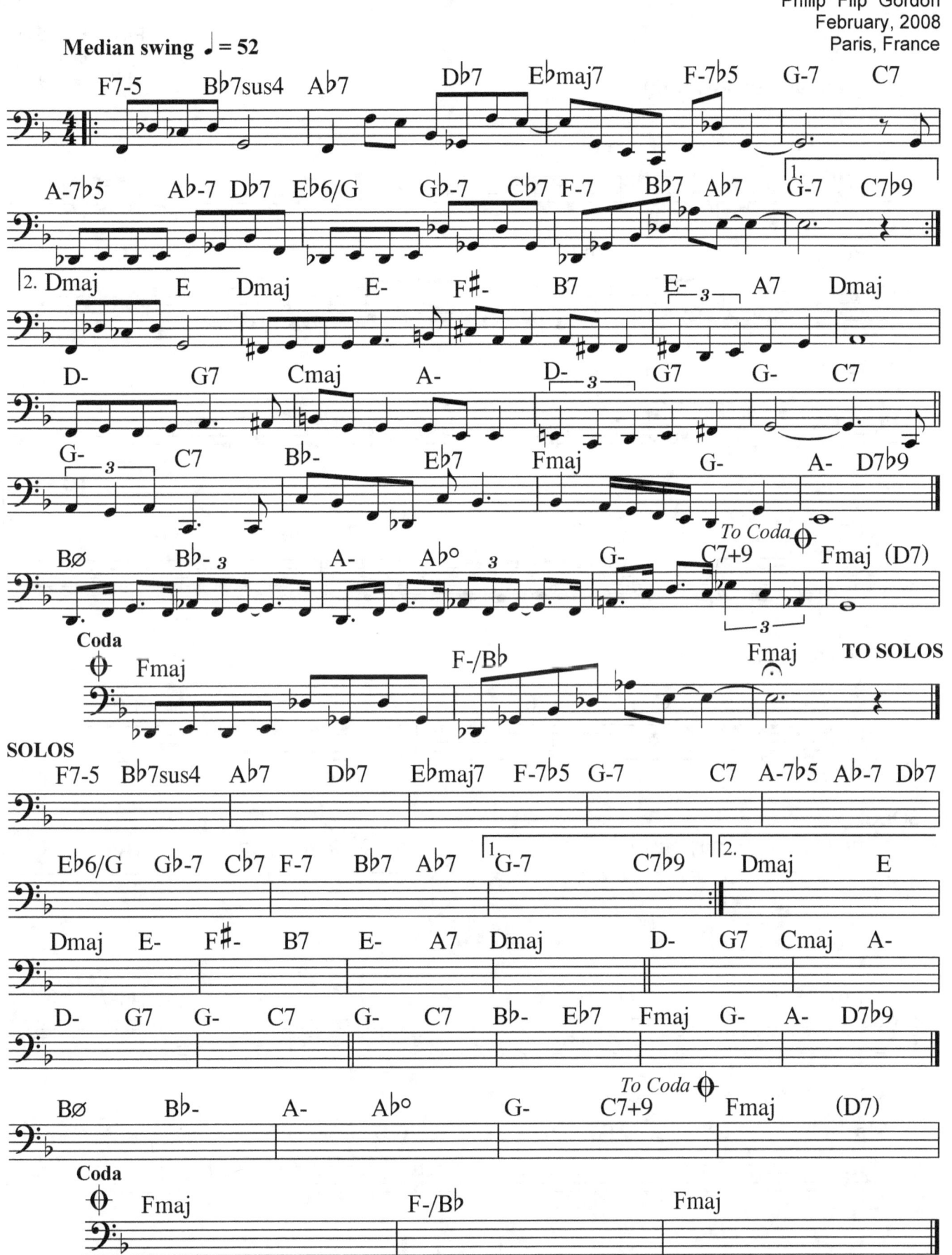

4. COUS-COUS for COCO

Philip "Flip" Gordon
January, 2004
Paris, France

5. WHY DON'T YOU JUST SPEAK WHALE TO ME?

Philip "Flip" Gordon
June, 2008
Paris, France

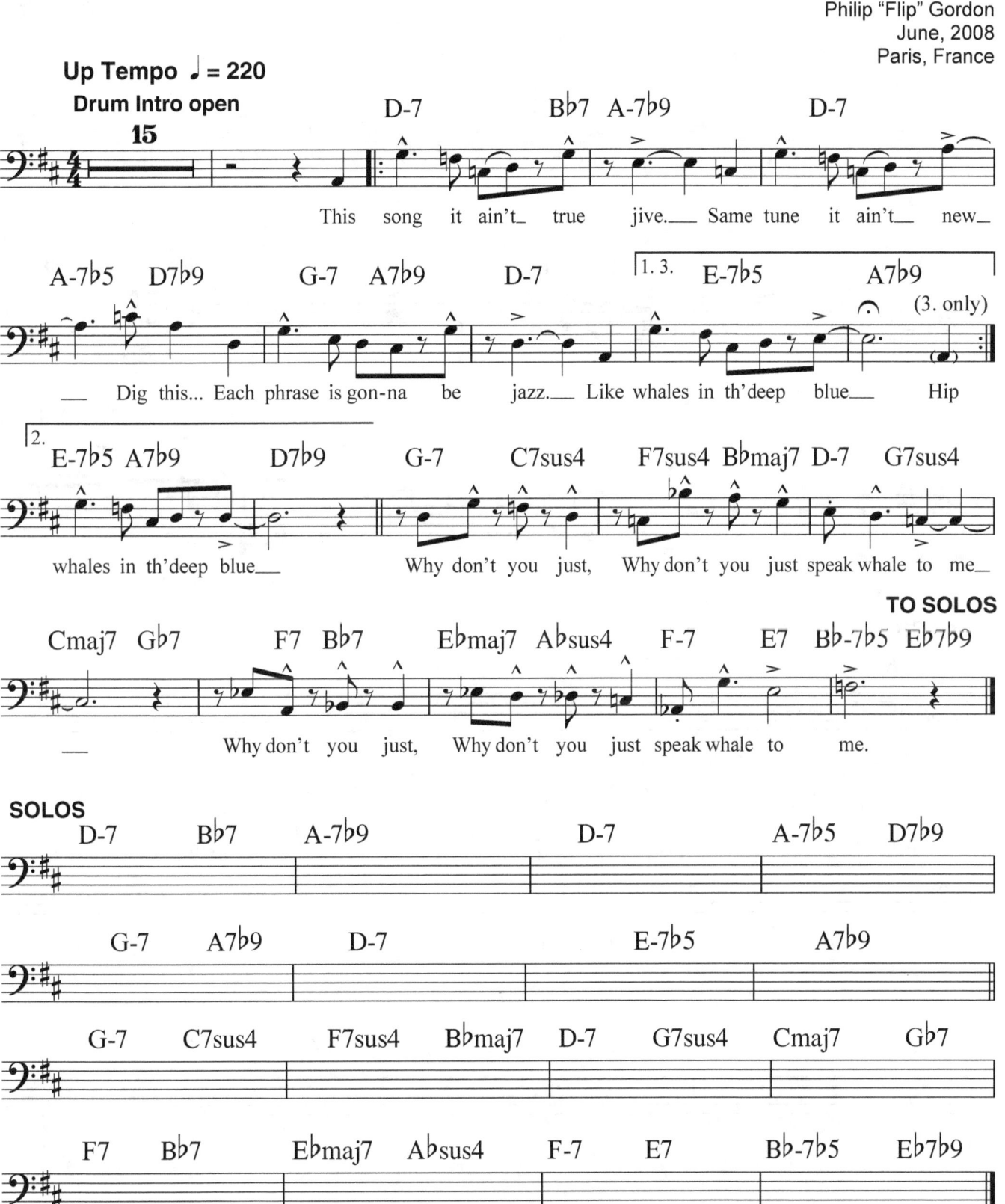

© All Rights Reserved, By Permission Only: Blue Matrix Productions

6. PORT ROYAL

Philip "Flip" Gordon
October, 2008
Paris, France

7. THREE-LEGGED DOG

Philip "Flip" Gordon
August, 2007
Paris, France

8. METRO BLUES

Philip "Flip" Gordon
January, 2004
Paris, France

9. CAUGHT BETWEEN a ROCK and a HARD PLACE

Rogers/Hart - Philip "Flip" Gordon
June, 2008
Paris, France

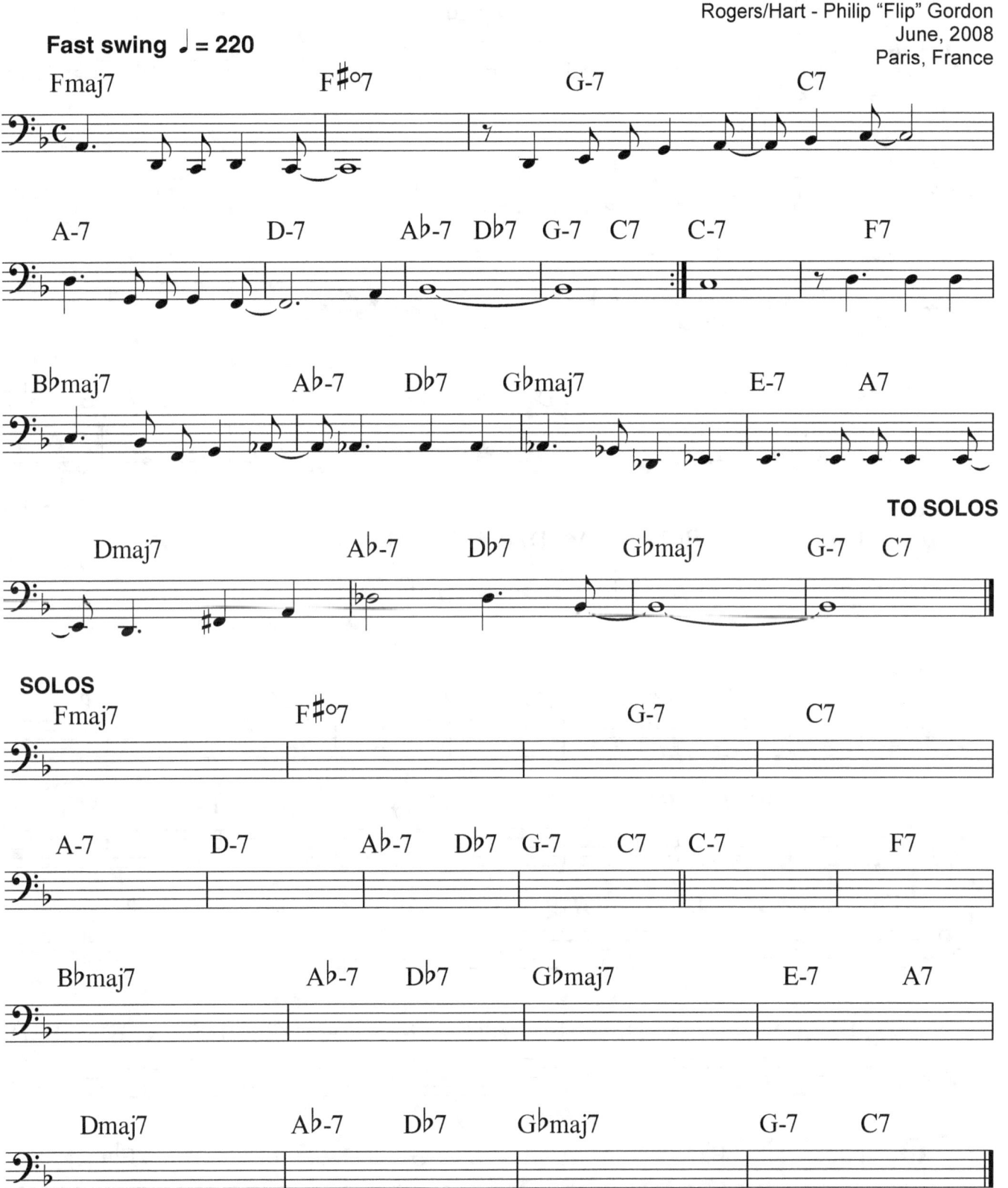

10. SECRETS D'HISTOIRE

Warden/Philip "Flip" Gordon
October, 2008
Paris, France

Swing ♩ = 168

11. SPRING CAN REALLY HANG YOU UP

Wolf/Gordon//Philip "Flip" Gordon
April, 2008
Paris, France

Median Ballad ♩ = 80

| Cmaj7 | B♭13 | Cmaj7 | Cmaj7 | B♭13 | Cmaj7 | B♭m7 | A♭maj7 |

| F♯m7 | Emaj7 | Dm7 | Cmaj7 | Am9 | Dm9 | G7 | Cmaj7 A7(♭9) |

| Dm7(11) A7($^{♭9}_{♯5}$) D9 G13 | Cmaj7 | B♭maj9 Cmaj7 | B♭maj9 Cmaj7 | Am7 Dm7 G7 |

| Em7 A7(♭9) F♯m7(♭5) | Fm7 Em7 | D7 Dm7 | G7 | Cmaj7 B♭maj7 |

| Cmaj7 B♭maj9 | Cmaj7 B♭maj9 | Cmaj7 Am7 | Dm7 G7 Em7 | A7(♭9) |

TO SOLOS

| F♯m7(♭5) Fm7 | Em7 | D7 Dm7 | G7 | Cm7 |

SOLOS

| Cmaj7 | B♭13 Cmaj7 | Cmaj7 | B♭13 Cmaj7 | B♭m7 A♭maj7 |

| F♯m7 Emaj7 | Dm7 Cmaj7 | Am9 Dm9 | G7 | Cmaj7 A7♭9 |

| Dm7(11) A7($^{♭9}_{♯5}$) D9 | G13 Cmaj7 | B♭maj9 Cmaj7 | B♭maj9 Cmaj7 | Am7 Dm7 G7 |

| Em7 A7(♭9) F♯m7(♭5) Fm7 Em7 | D7 | Dm7 | G7 | Cmaj7 B♭maj7 |

| Cmaj7 B♭maj9 | Cmaj7 B♭maj9 | Cmaj7 Am7 | Dm7 G7 Em7 | A7(♭9) |

| F♯m7(♭5) Fm7 | Em7 | D7 | Dm7 | G7 | Cm7 |

© All Rights Reserved, By Permission Only: Blue Matrix Productions

12. SKATING IN CENTRAL PARK TOO

John Lewis
Adapted Philip "Flip" Gordon
August, 2008
Paris, France